BUTTERFLY BUDDHA

Butterfly Art Studio & Studio3B

PEACE & HAPPINESS

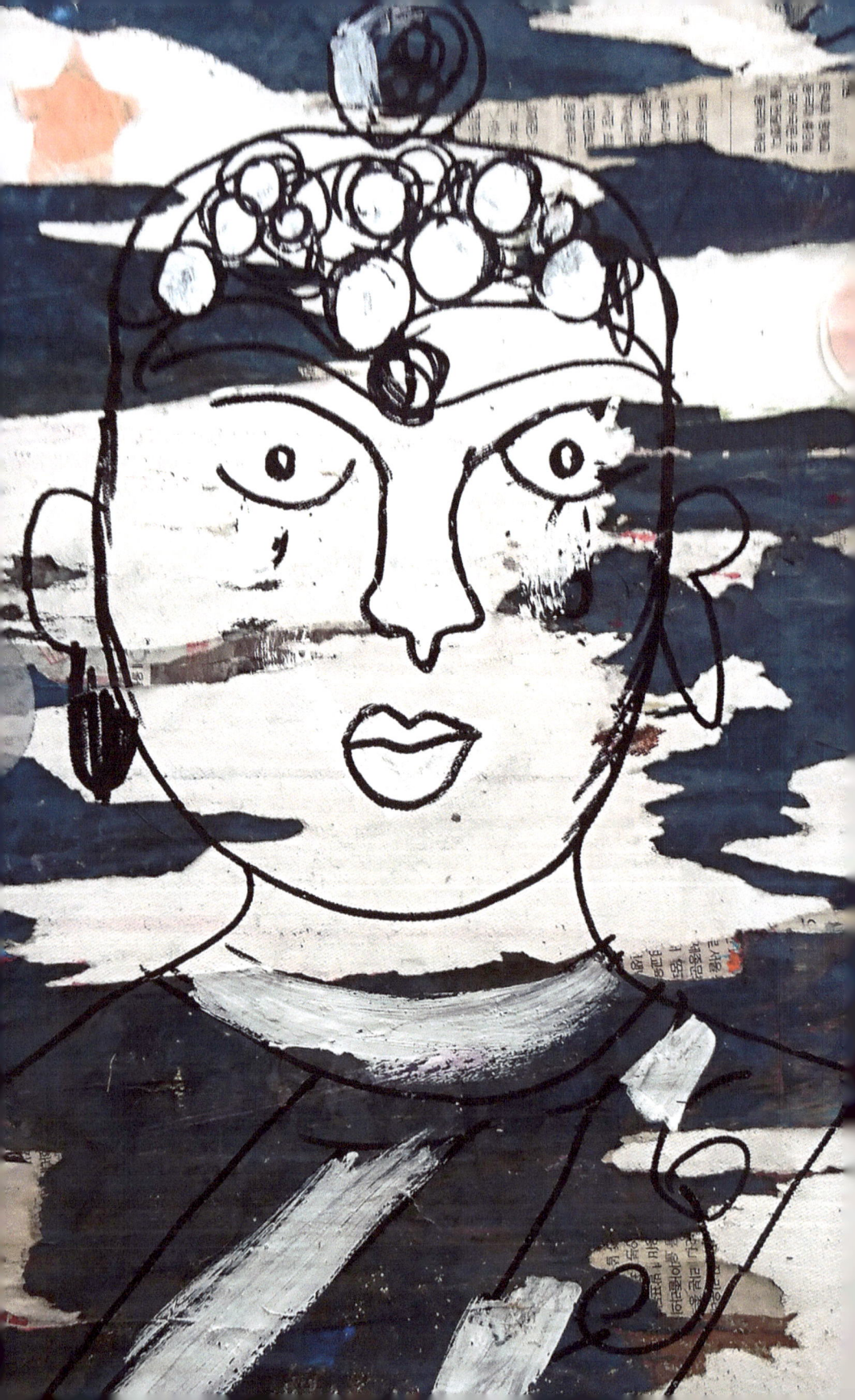

អ្វីៗនៅលើលោកកើតមកហើយ គួរតែបញ្ចប់ទៅវិញ។

ធ្វើអ្វីៗដែលល្អបង្កើតសេចក្តីសុខរបស់អ្នក។

Everything

that has a beginning

has an end.

Make your peace with that

and All

will be well.

Sok Pich, *age 13*

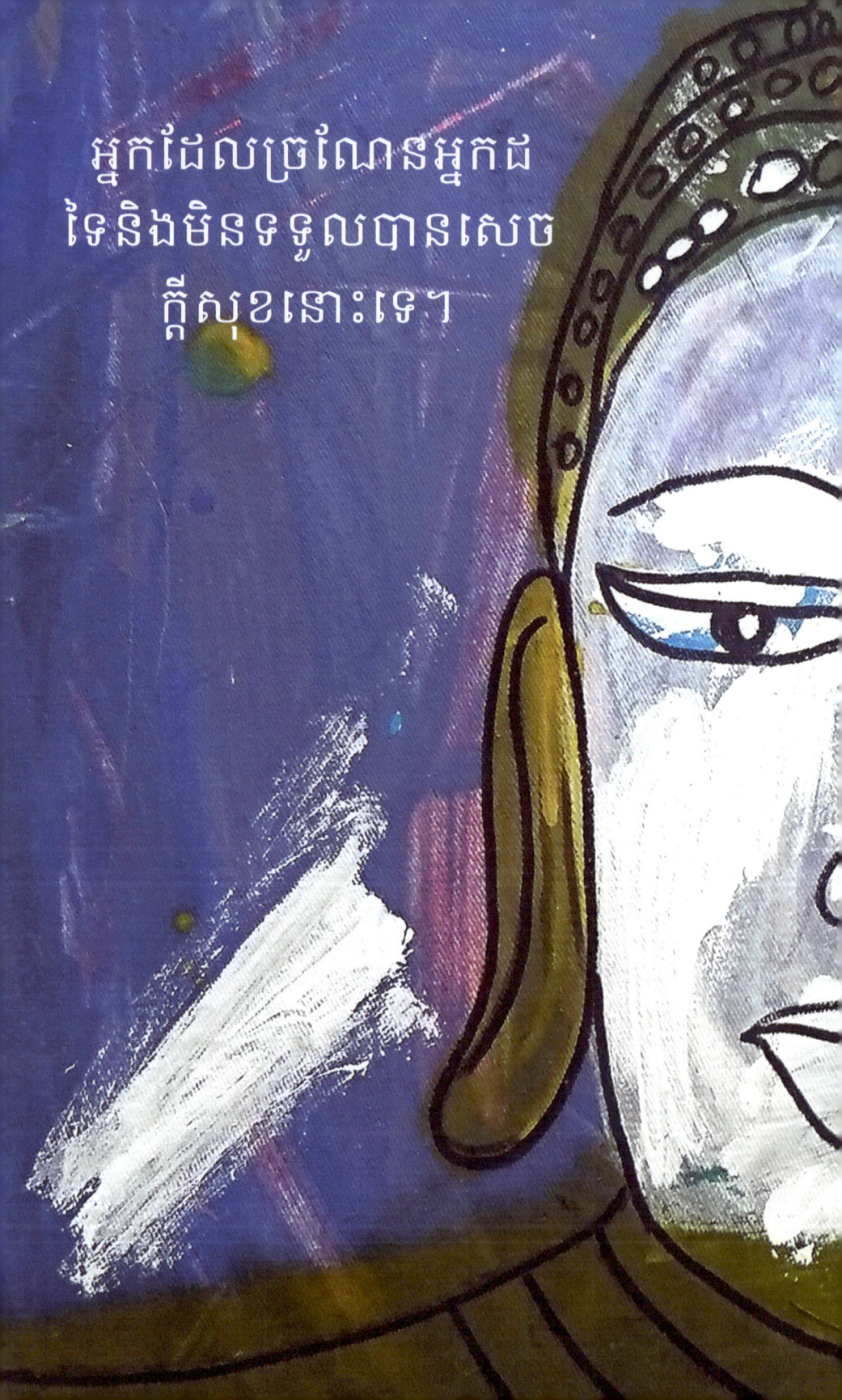

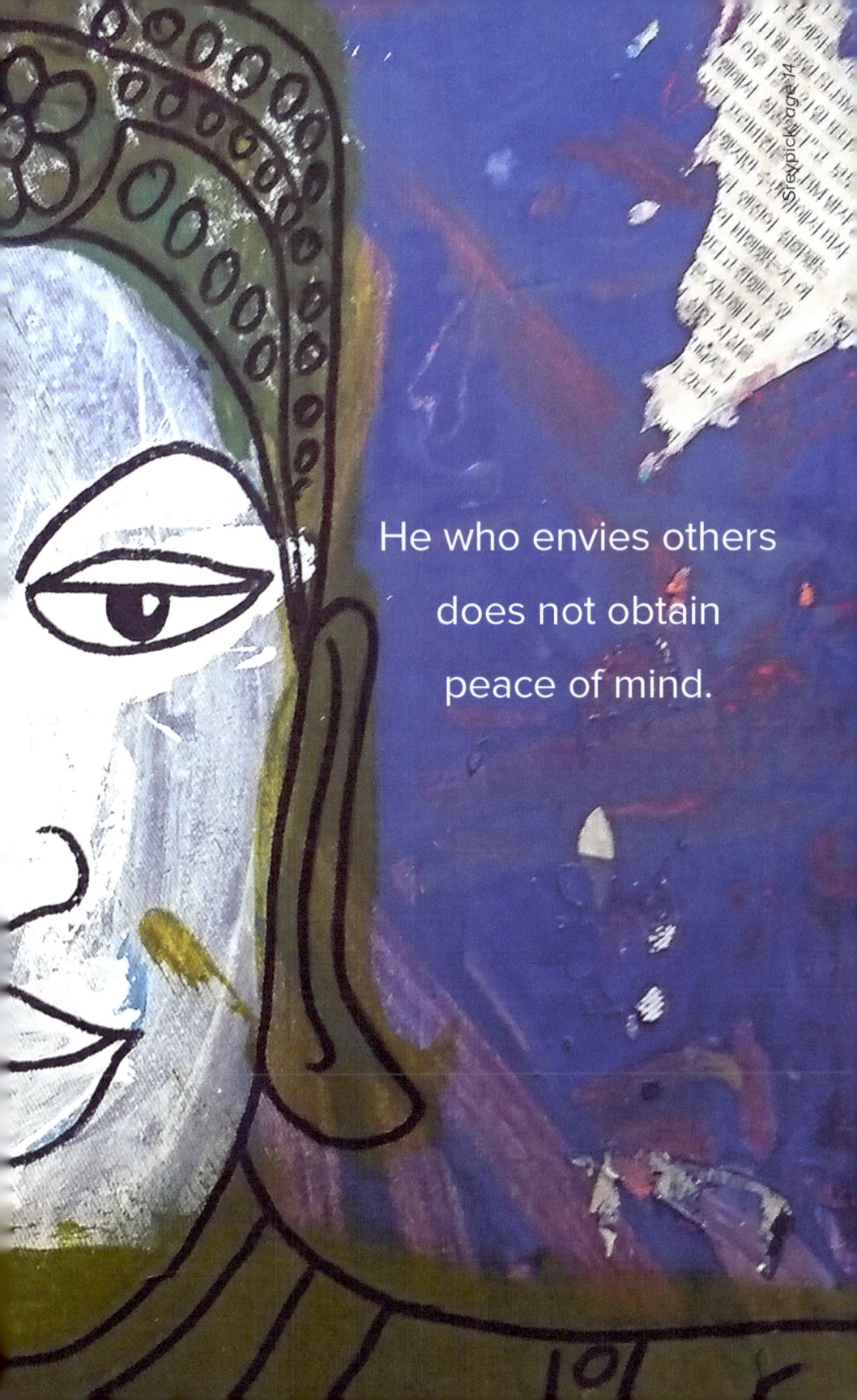

មិនមានផ្លូវសុខភមង្គលនោះទេ។
សុខភមង្គលទើបជាផ្លូវ។

There is no way

to happiness.

Happiness *is* the way.

Samnang, *age 12*

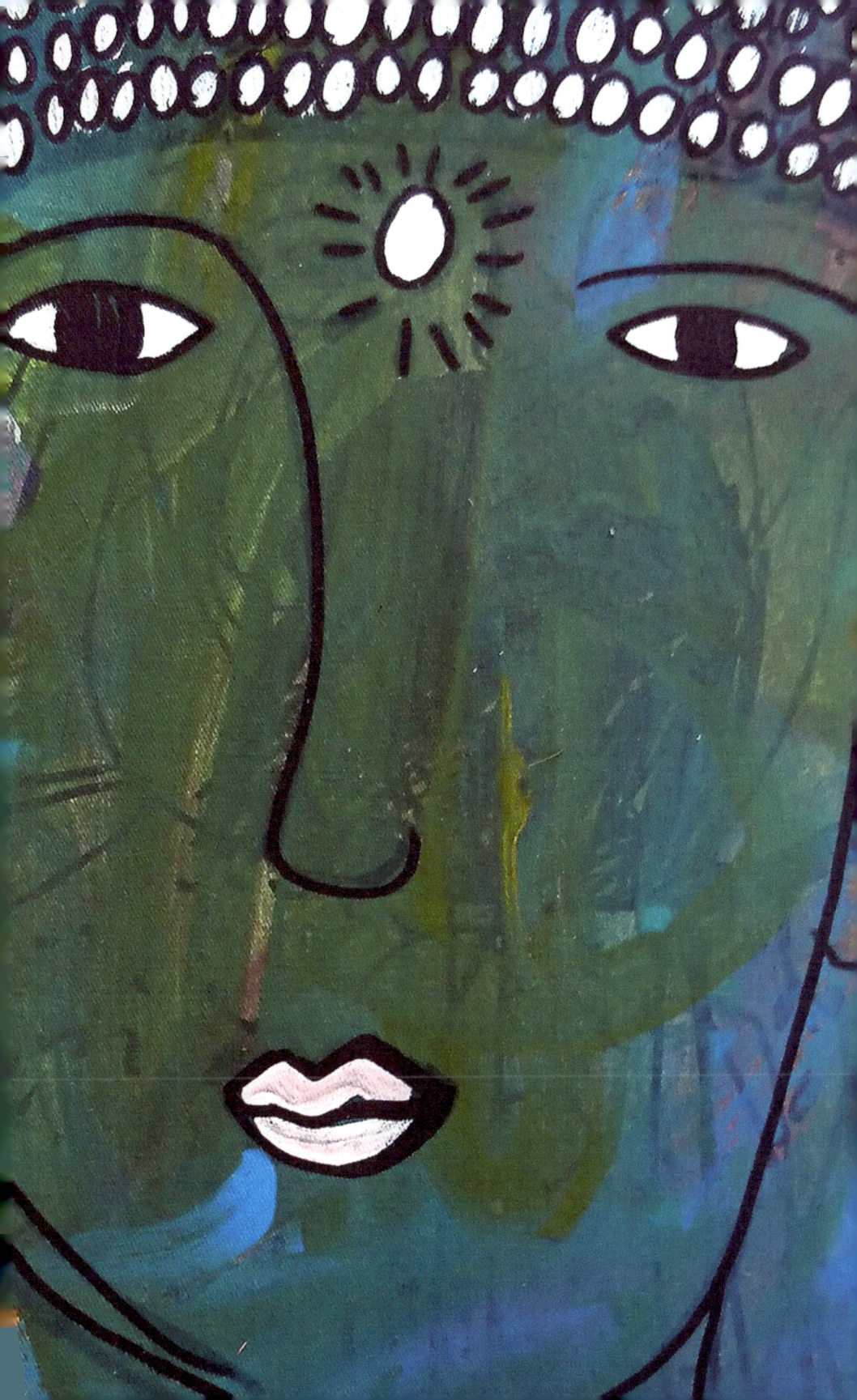

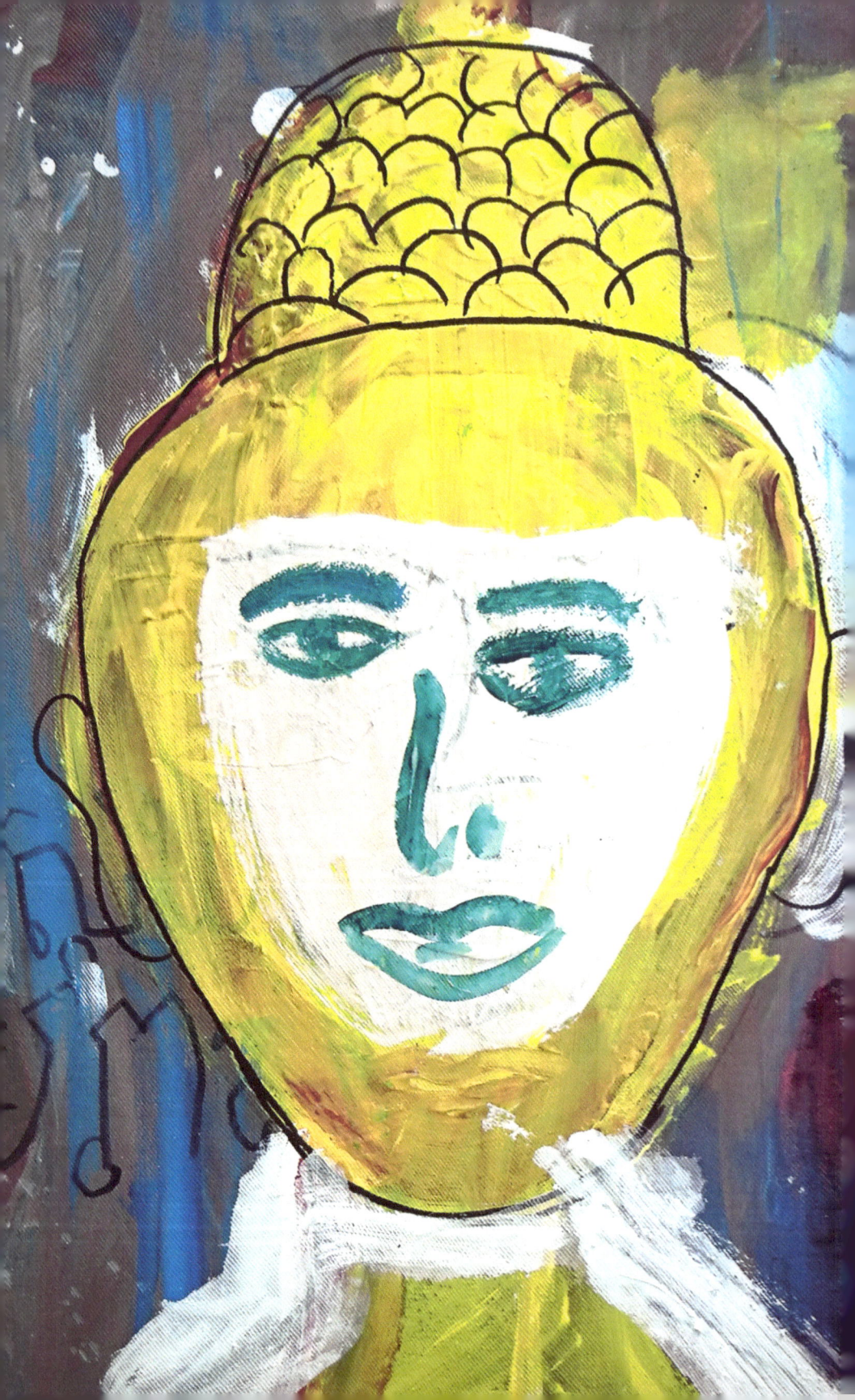

បើសិនមានគំនិតហើយត្រូវបានមនុស្សនិយាយឬក៏ធ្វើនៅពេលនោះសុខភមង្គលនិងដើរតាមពួកគេដូចជាស្រមោល។

If with a pure mind

a person speaks or acts,

happiness follows them

like a never-departing

shadow.

Makara, *age 16*

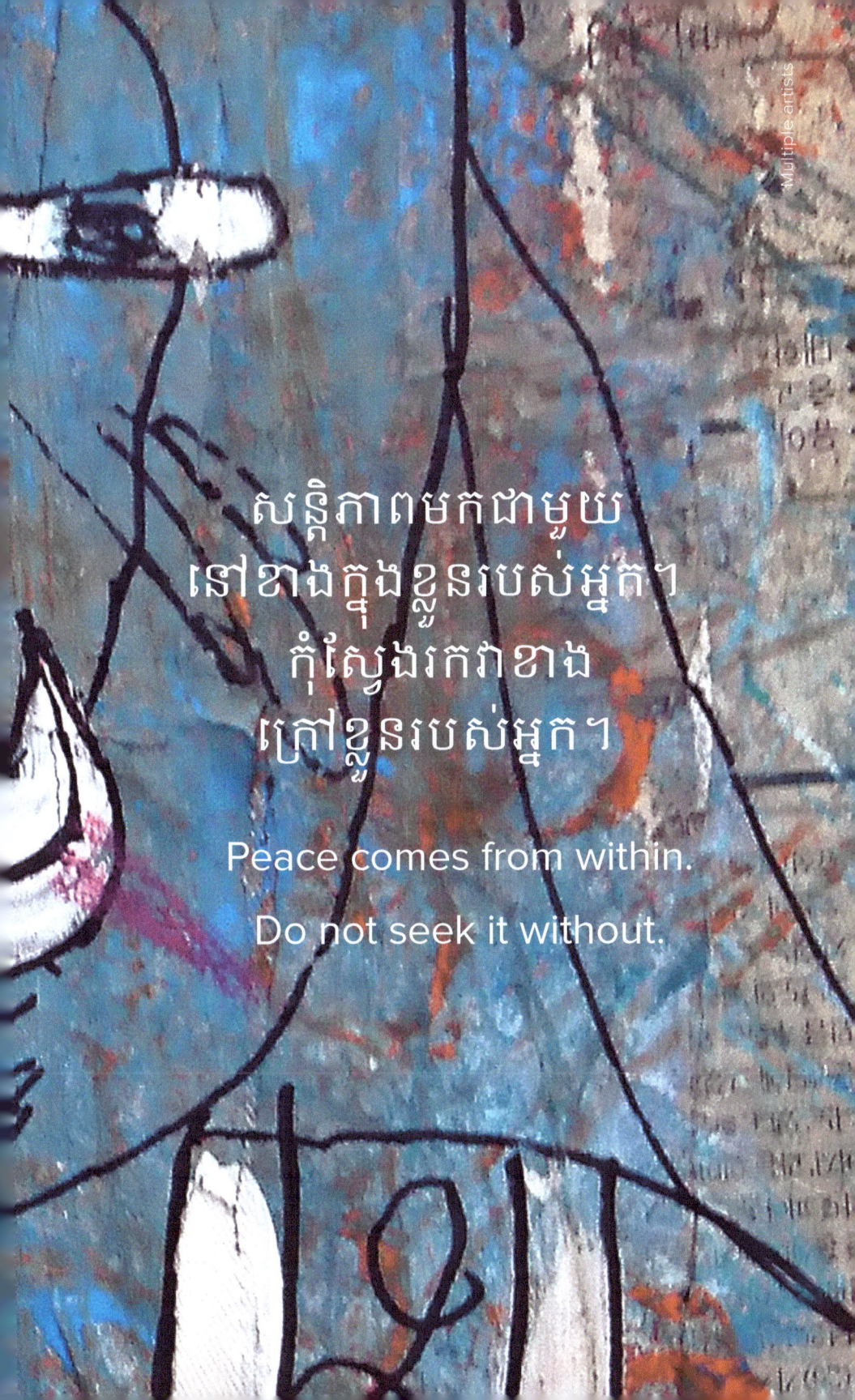

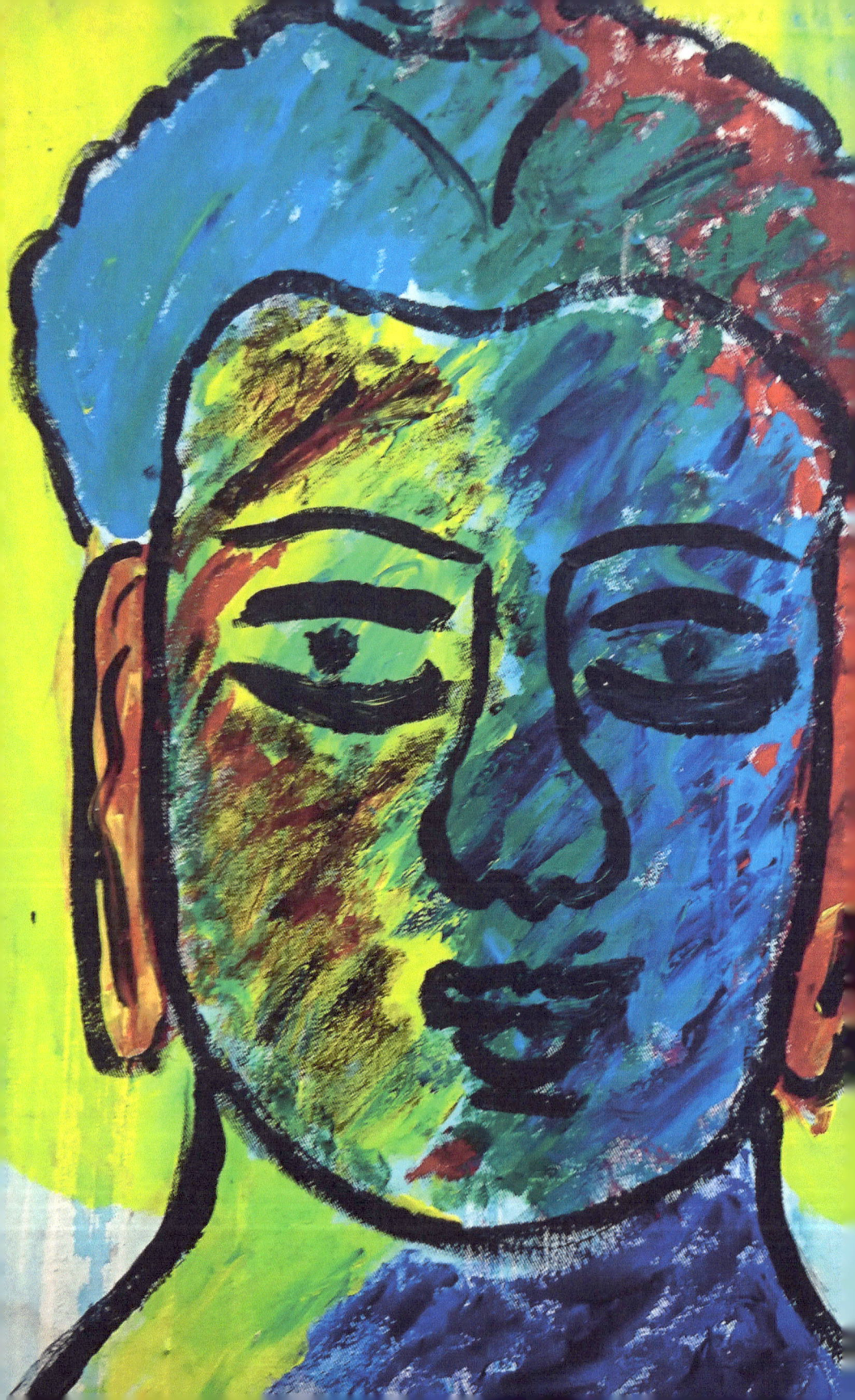

ប្រសើរជាងមួយពាន់ពាក្យប្រហោងគឺជាពាក្យមួយដែលនាំមកនៅសន្តិភាព។

Better than

a thousand hollow words

is one word

that brings peace.

Bocheat, *age 15*

វាគឺជារឿងធម្មជាតិអំណរដែលកើតឡើងនៅក្នុងខ្លួនមនុស្សឥតគិតថ្ងៃពីវិប្បដិសារី។

It is in the nature of things

that joy arises

in a person

free from remorse.

Tieing, *age 15*

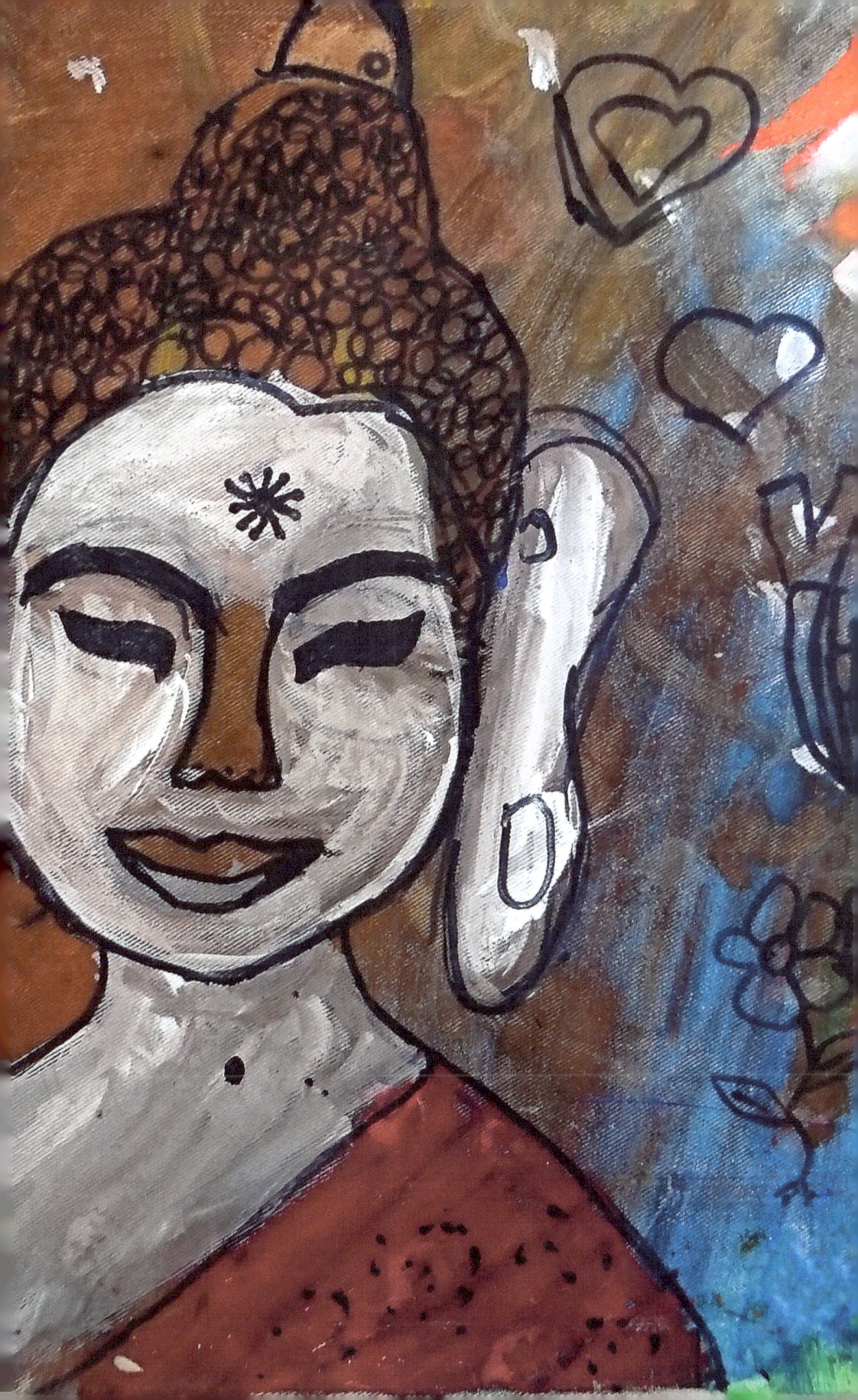

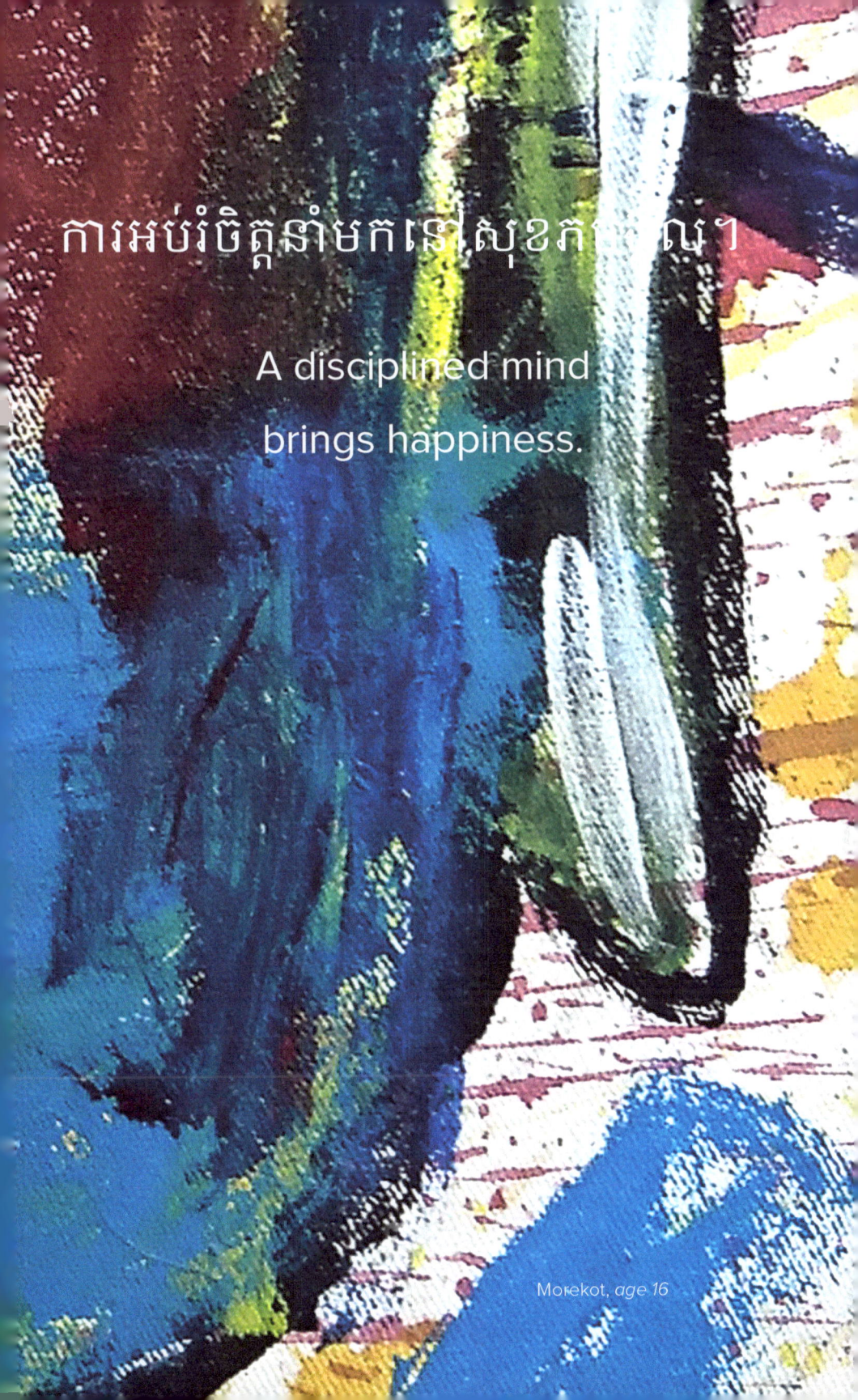

ការអប់រំចិត្តនាំមកនៅសុខភាពល។

A disciplined mind brings happiness.

Morekot, *age 16*

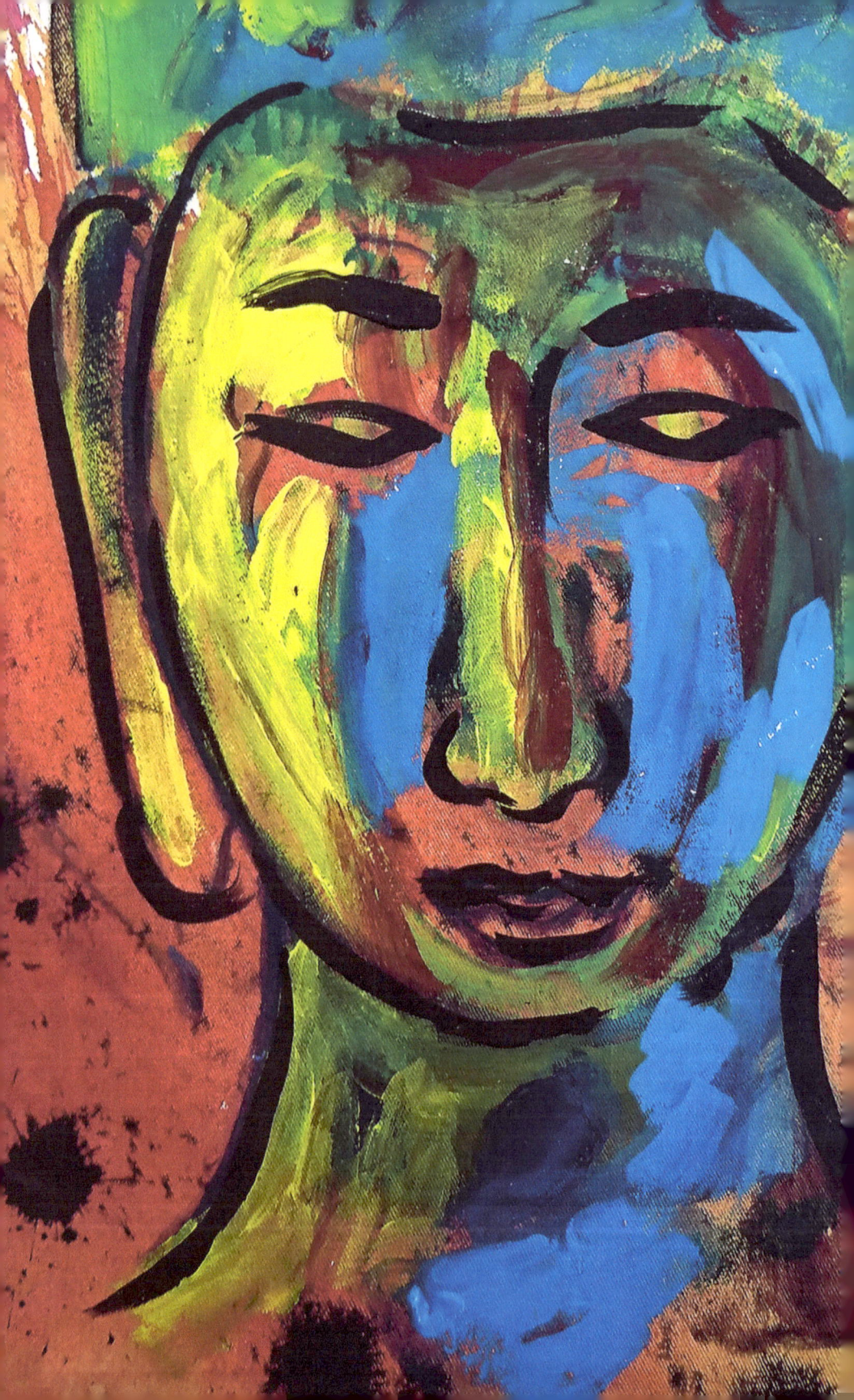

ប្តេជ្ញាហ្វឹកហាត់ខ្លួនឯ ងដើម្បីទទួលបានសន្តិភាព។

Resolutely

train yourself

to attain peace.

Vandy, *age 14*

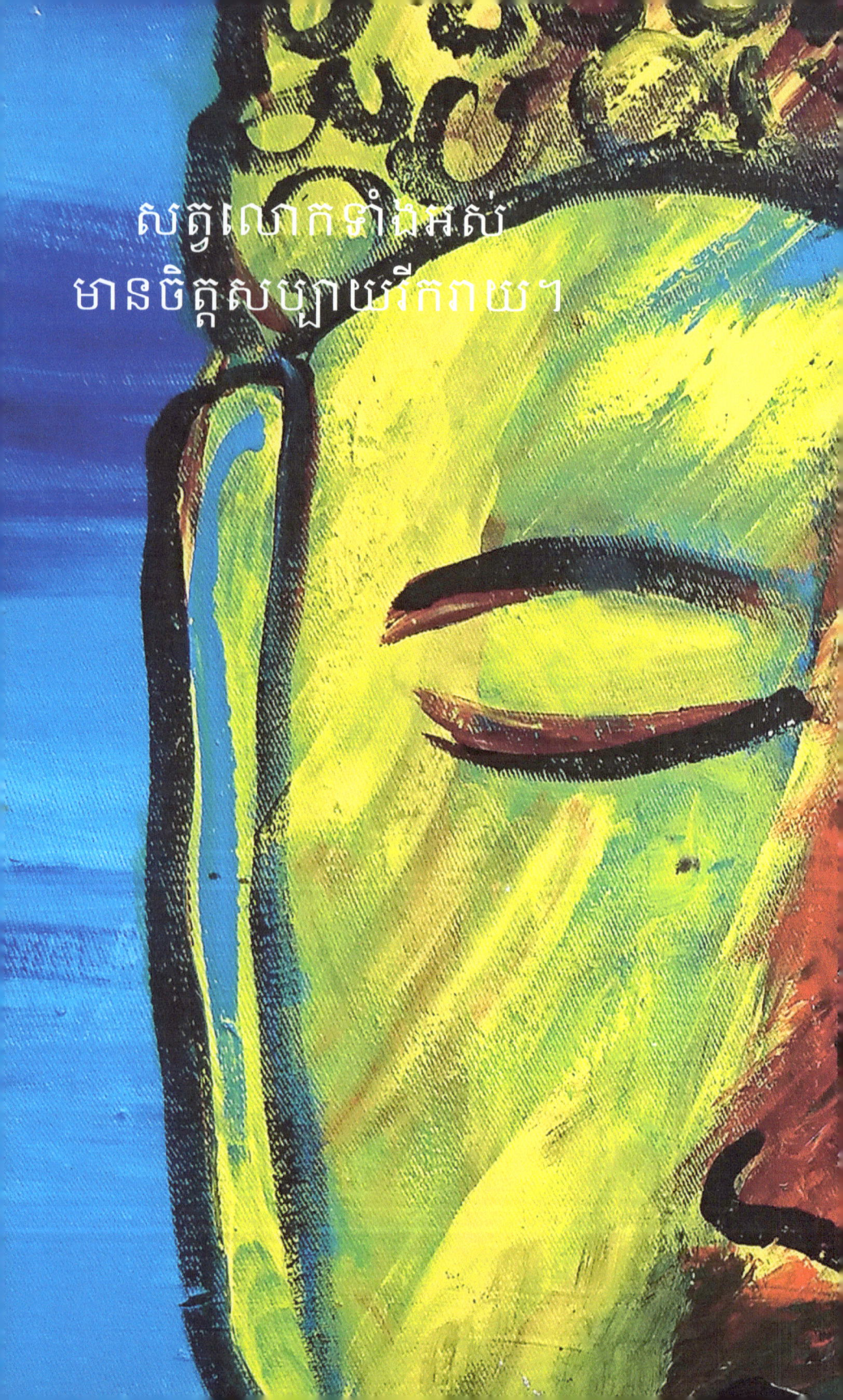

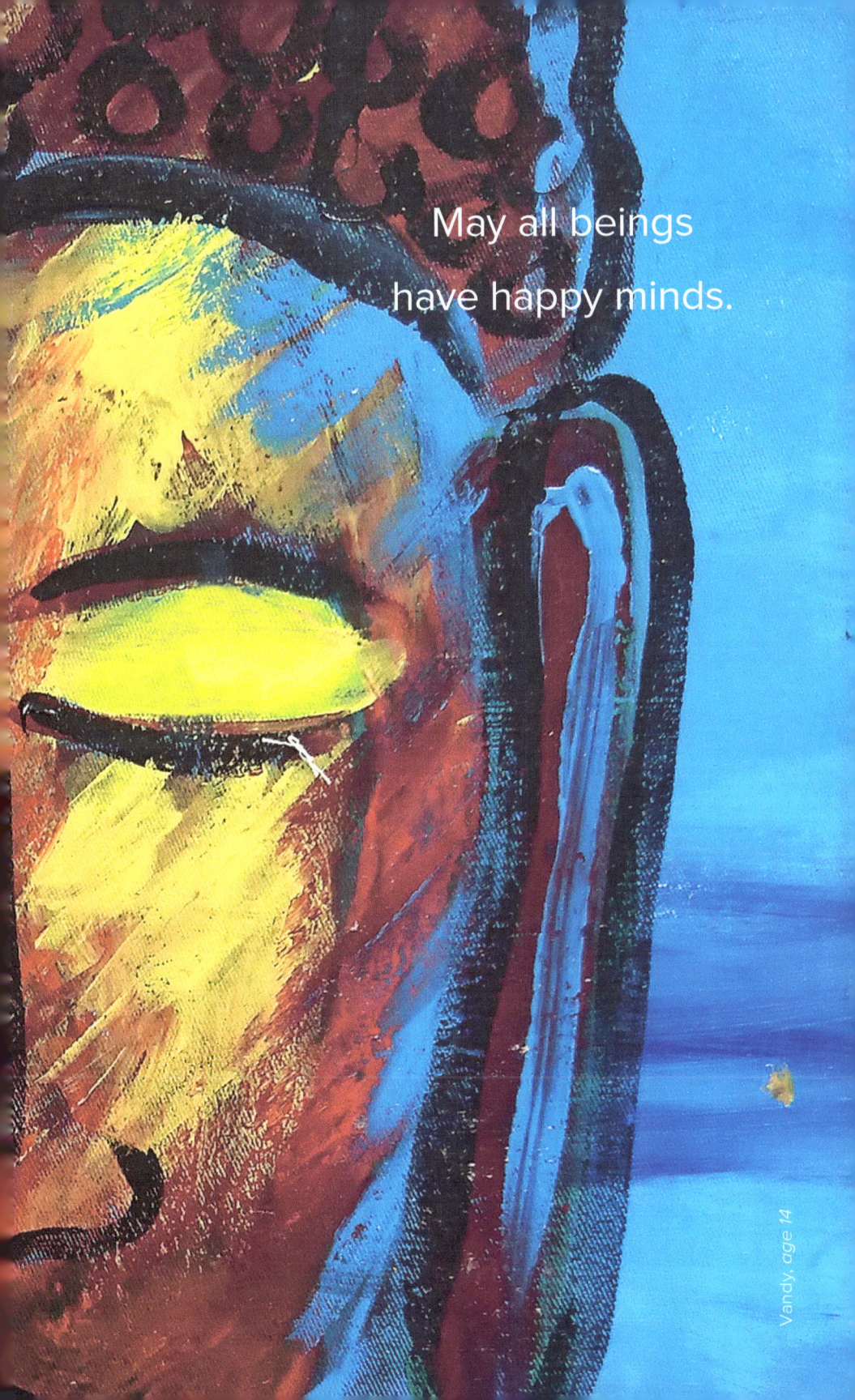

TO SUPPORT THE BUTTERFLY ARTISTS
& YOURSELF

COLLECT THE WHOLE SERIES

May you be peaceful and at ease.

All paintings created by Cambodian children
at Butterfly Art Studio, Siem Reap, Cambodia.

All quotes spoken by Lord Buddha, Siddhārtha Gautama

Design by Studio3B

www.ingramcontent.com/pod-product-compliance
Lightning Source LLC
Chambersburg PA
CBHW041212180526
45172CB00006B/1245

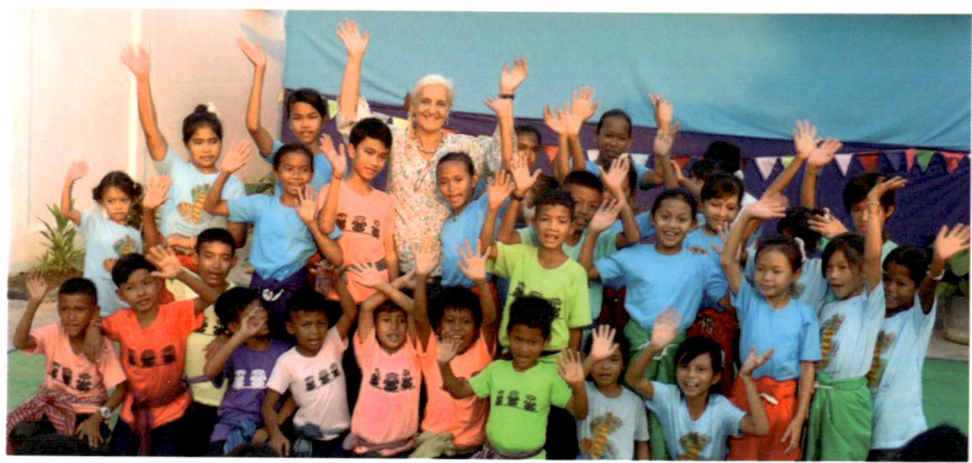

 BUTTERFLY ART STUDIO
Siem Reap, Cambodia

🇫 Butterfly Art Studio Cambodia

🌐 helpchildrencambodia.com

Free daily classes for children
who wish to learn a new skill or
enjoy the creative process in :

– Drawing
– Arts & Crafts
– Sewing
– English &
– Khmer Dance

For donations & volunteering opportunities,
please contact Ana :

🇫 Ana Margarida Alberty

Thematic Butterfly Buddha Books available online at major bookstores :

– Love
– Peace & Happiness
– Giving
– Health
– Actions
– Understanding

100% of all proceeds go towards
maintaining and expanding the studio
and activities on offer.

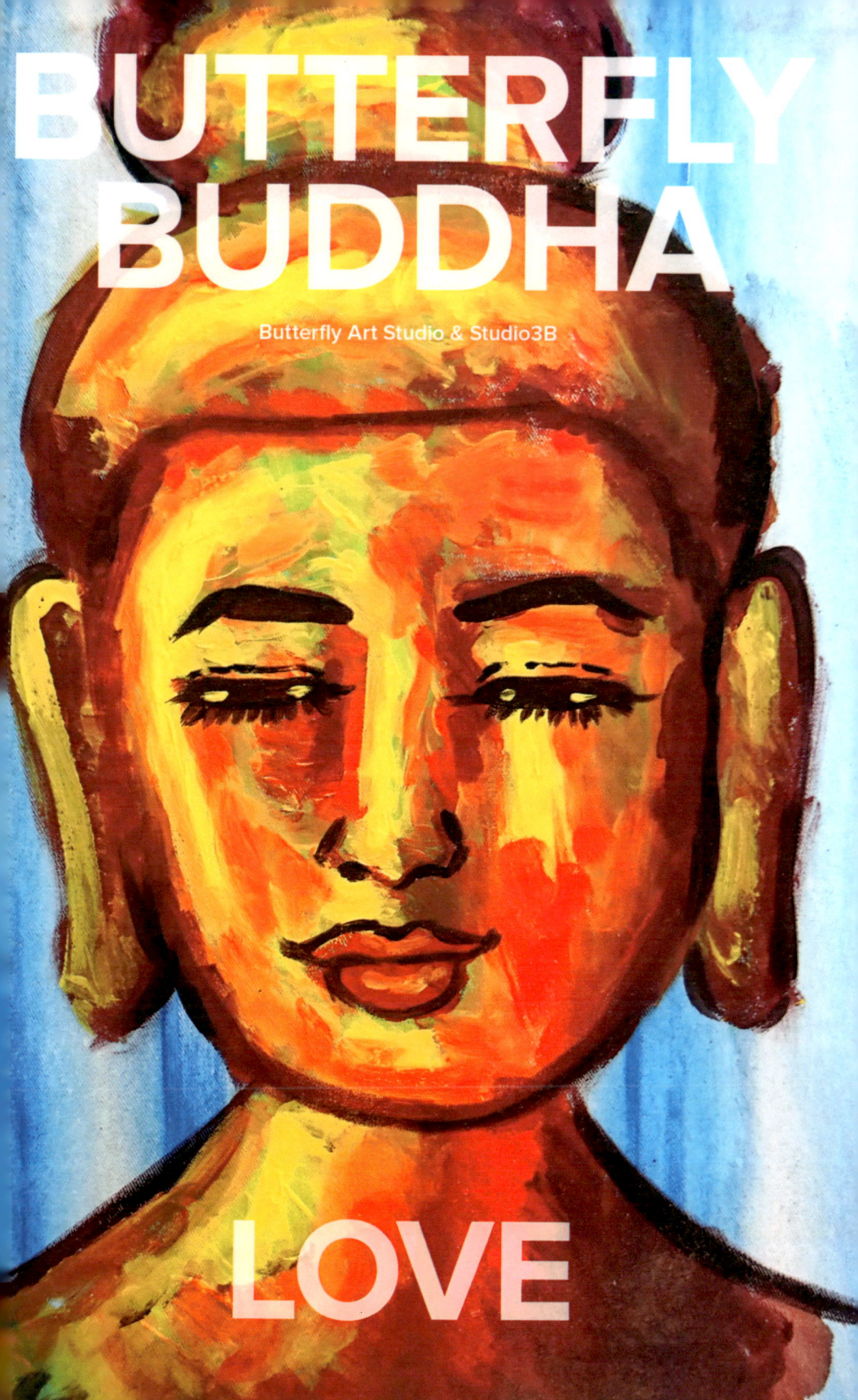